morelabradorable

morelabradorable

Follow the adventures of Barnaby the labrador and his friends

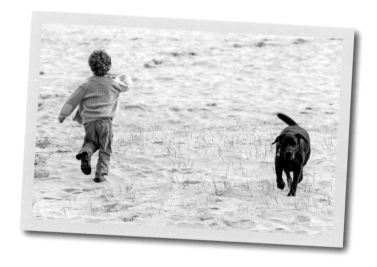

Villager Jim

CICO BOOKS
LONDON NEW YORK

Published in 2017 by CICO Books
An imprint of Ryland Peters & Small Ltd
20–21 Jockey's Fields, London WC1R 4BW
341 E 116th St, New York, NY 10029
www.rylandpeters.com

10 9 8 7 6 5 4 3 2 1

Text and photography © Villager Jim 2017
Design © CICO Books 2017

A CIP catalog record for this book is available from
the Library of Congress and the British Library.

ISBN: 978 1 78249 447 8

Printed in China

Designer: Geoff Borin
Art director: Sally Powell
Head of production: Patricia Harrington
Publishing manager: Penny Craig
Publisher: Cindy Richards

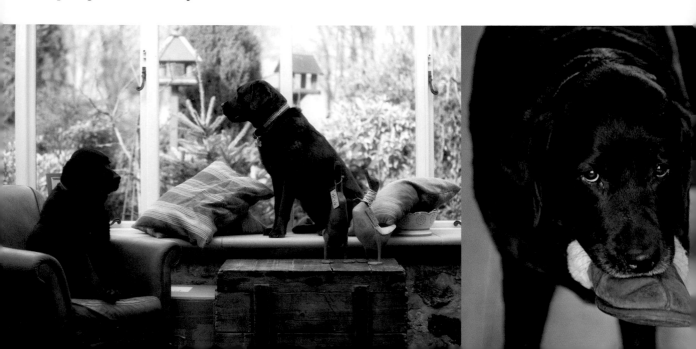

contents

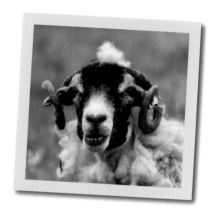

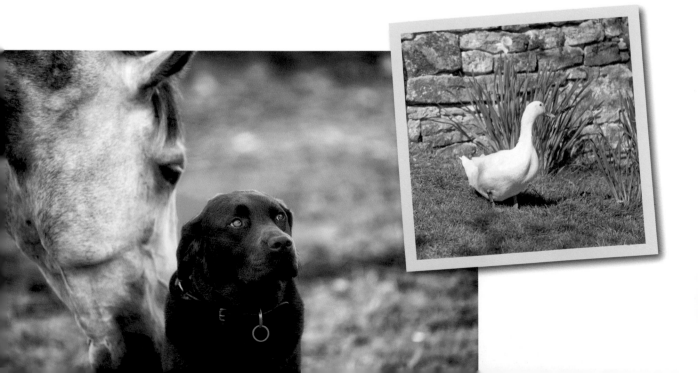

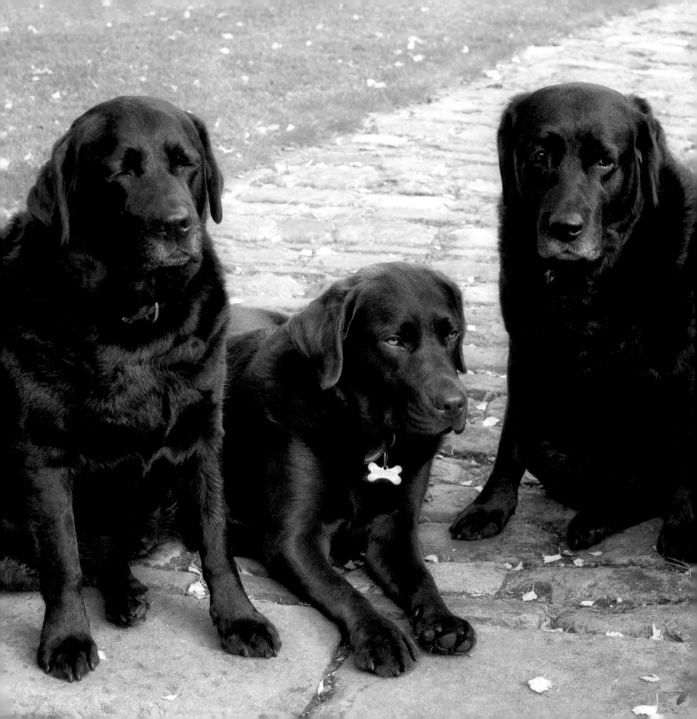

introduction

Morelabradorable! Following the success of our first book, **Labradorable,** how could we not publish more adventures of the most famous labs in Britain—Bumble, Dilly and the new boy in town Barnaby, who has already gained a cult following of lab lovers with his daily adventures online. Villager Jim, one of the fastest growing internet photographers on social media, captures the antics of these gloriously happy labradors, and the animals they meet, on their farm in the Peak District National Park and on their walks in the surrounding countryside. The two older sisters Bumble and Dilly have to cope with the boundless energy of the ball of brown fur that is Barnaby, and his constant need for love and attention from them. And as if that wasn't enough, he steals every treat they are given, with the stealth and speed of a ninja, but he's ready to win them over with his big puppy-dog eyes if they catch him!

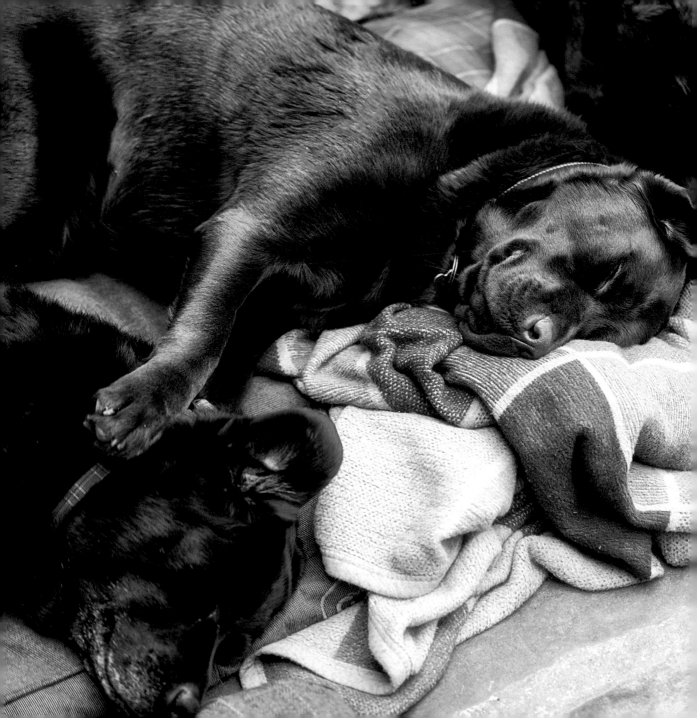

faithful
friends

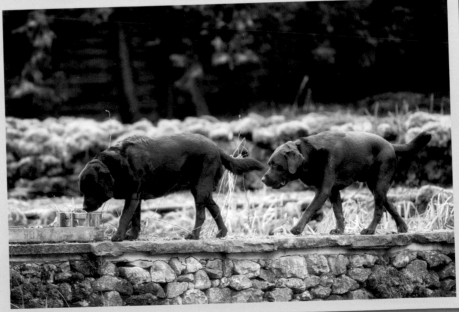

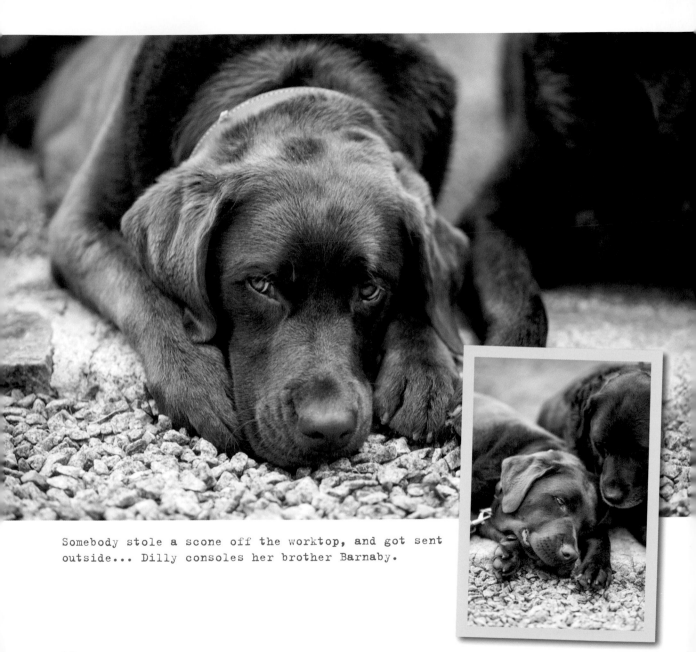

Somebody stole a scone off the worktop, and got sent outside... Dilly consoles her brother Barnaby.

10

"Mum! When you come home I'll have your slippers
nice and warm for you..."

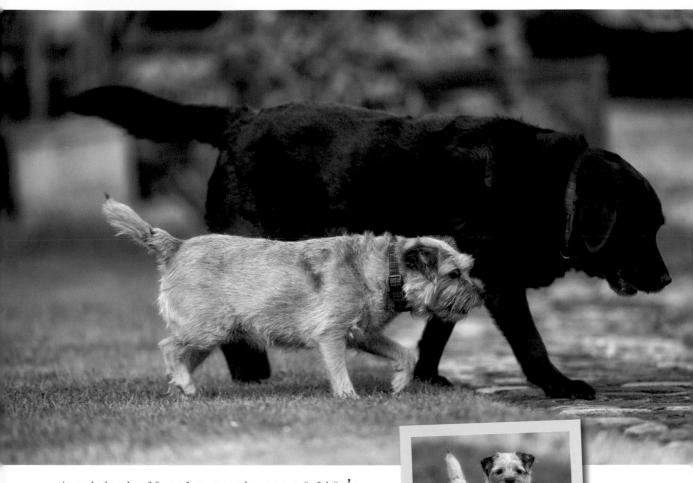

A quiet stroll and a gossip—one of life's
simple pleasures.

Gerty, Barnaby's long time girlfriend and
walk buddy, waits for him to join her in
the garden.

Gerty gets a talking to from Barnaby's big sisters. They are just making sure she isn't after his money!

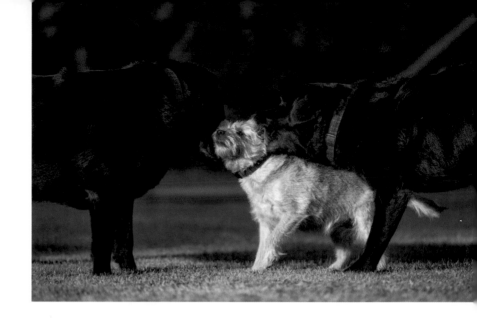

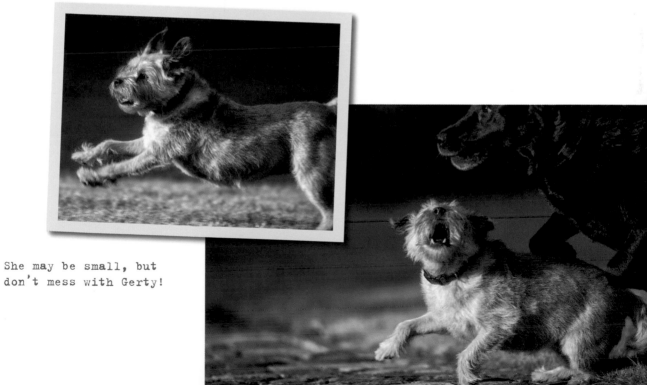

She may be small, but don't mess with Gerty!

My good chum Mark came round today, and his faithful pooch
Chip let me know in no uncertain terms what he thought of
being snapped by my camera!

14

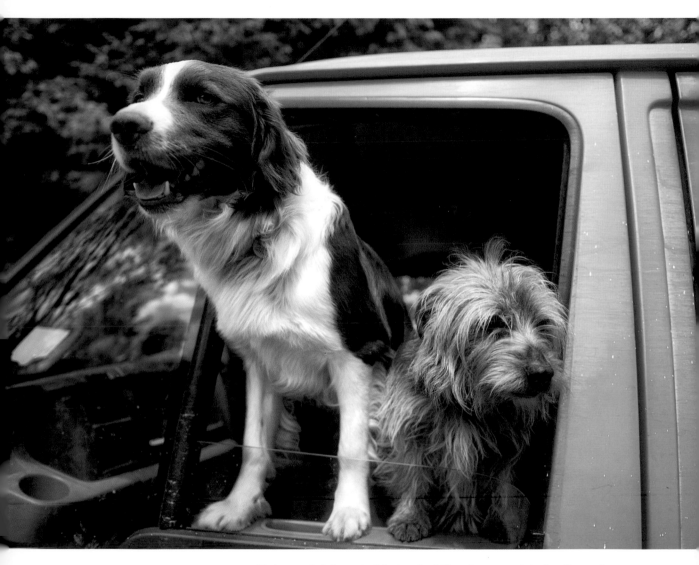

Chip and his girlfriend like to say hi to Barnaby on their flying visits. They come to deliver more logs for that cozy fire that all the dogs like to sleep beside!

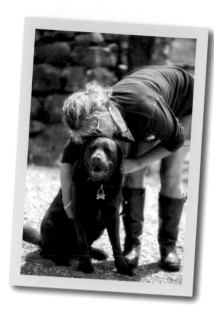

"I've been good today and not jumped up to say hello to anyone in smart clothing, so I think I deserve a kiss."

"I love walking with mum—we go to Ashford in the Water a small but beautiful village in the Peak District that has a river running through it, where I try to catch the trout!"

"So Barnaby, we are going to walk through those woods, up the hill there, turn right..."

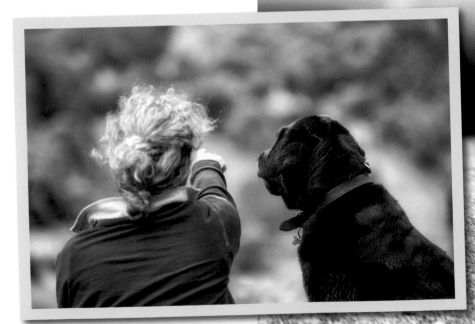

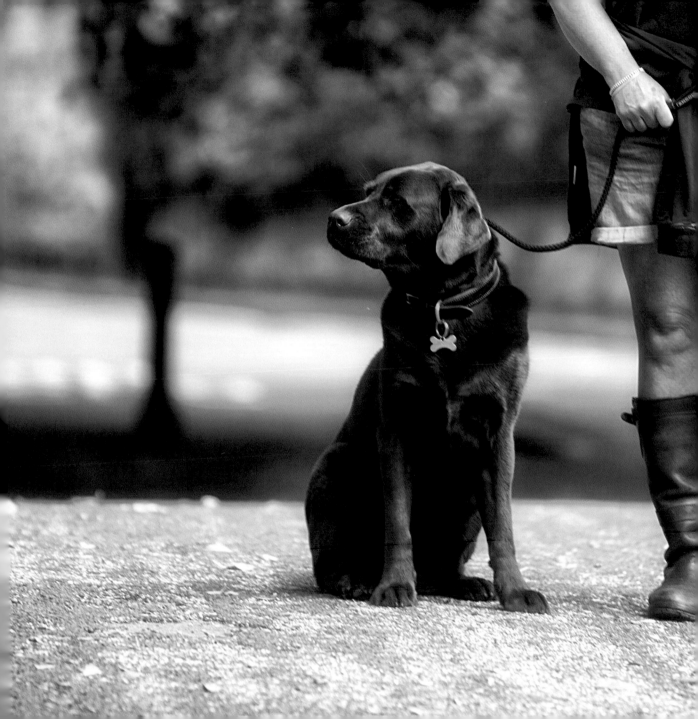

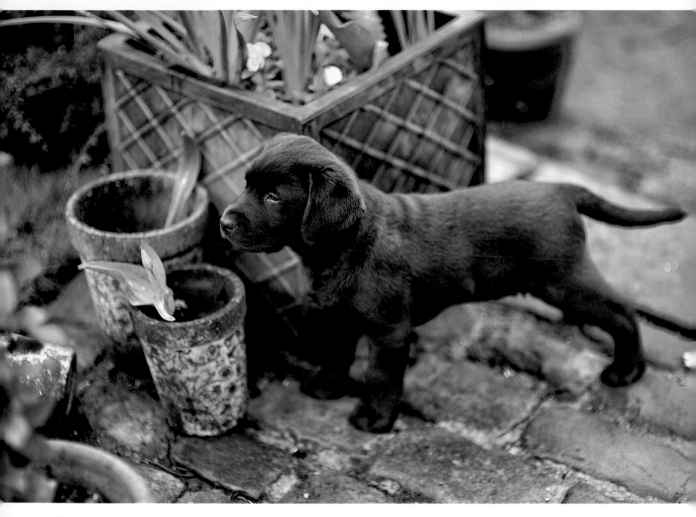

"This is me in my younger days, as you can see I was
big and tough right from day one."

Right: "Hey Bumble give it back! It's not
yours, give it back right now. Mum!!"

18

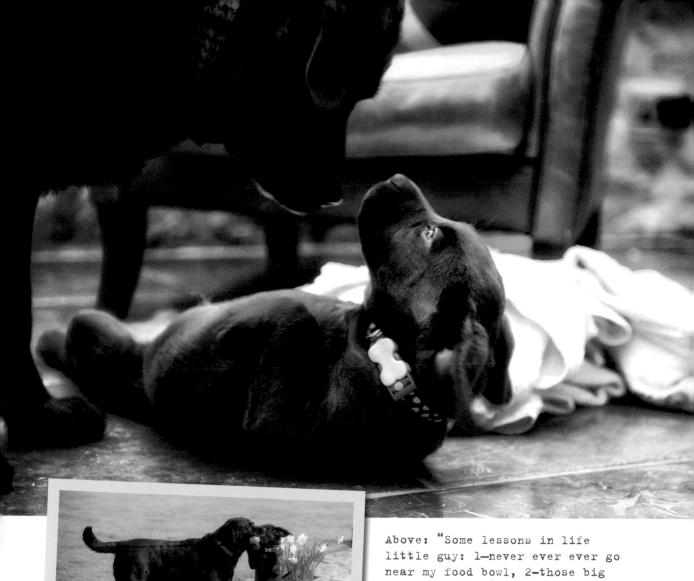

Above: "Some lessons in life little guy: 1—never ever ever go near my food bowl, 2—those big brown eyes don't work on me, so watch it; and 3—Mum won't think showing her your tummy is cute, when she sees what you've done in the boot room."

Footy with pals is always so much fun....

Gerty plays midfield, and Barnaby?
He's all over the place.

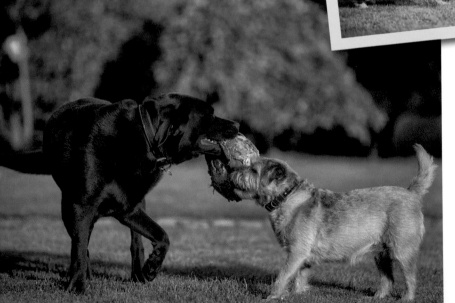

"Here, you hold the ball
Gerty, while I go and
tell dad it's burst...
how did that happen?!"

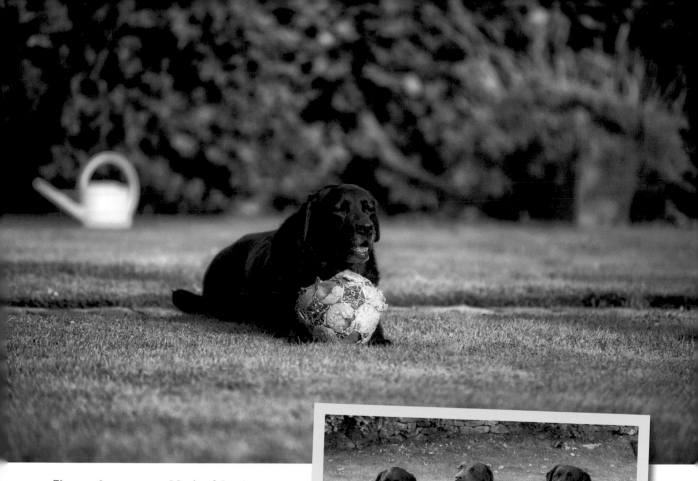

The refereree, all in black,
holds on to the ball as evidence.

The team photo is always
a highlight for these
talented amateurs.

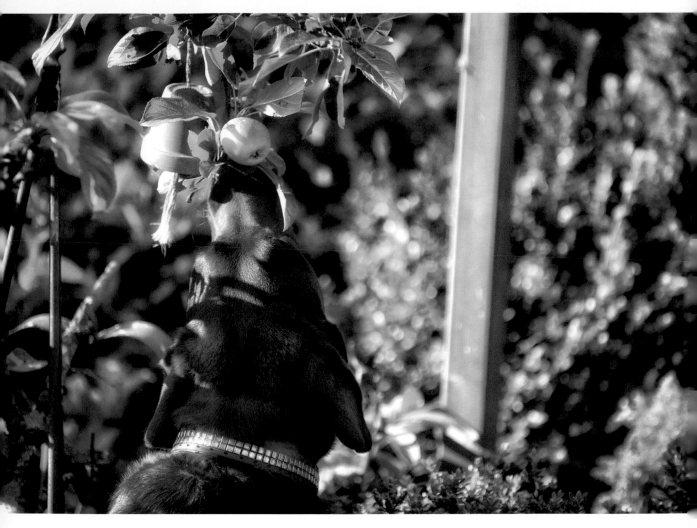

Sometimes it seems that Barnaby's best friend is his stomach. I came home one day and found the little monkey taking the apples from the tree. I had been wondering for weeks where they were all going

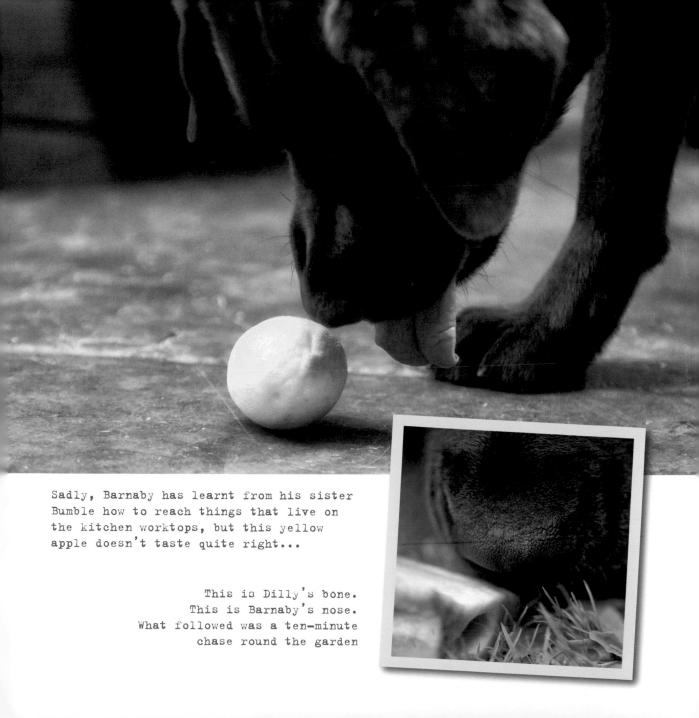

Sadly, Barnaby has learnt from his sister
Bumble how to reach things that live on
the kitchen worktops, but this yellow
apple doesn't taste quite right...

This is Dilly's bone.
This is Barnaby's nose.
What followed was a ten-minute
chase round the garden

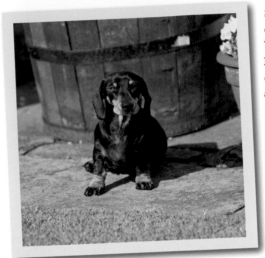

Say hello to Rambo! This is Barnaby's next door neighbour and as you can see he's big and very, very tough. He's taken off his bandana for this photograph, but that doesn't hide how dangerous he could be at a moment's notice.

And this is Daisy, Rambo's girlfriend. She's a little bit shy.

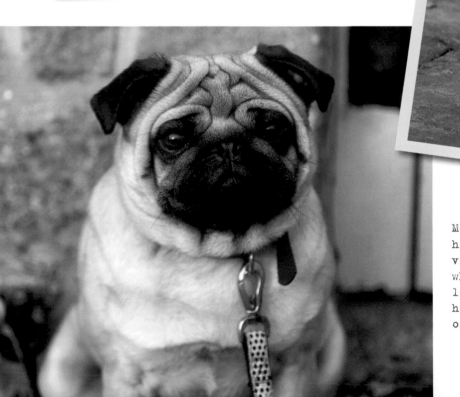

Meet Frank. We see him in the next village along from where we live. Frank looks serious, but he's really a bundle of fun.

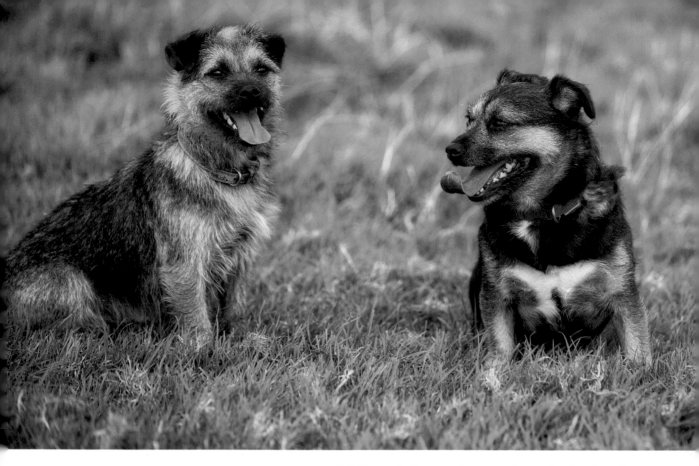

Sybil and Geegee have a two-minute break
from going crazy round the fields.

"Mum, there's a big brown dog
over there and he's scaring me."

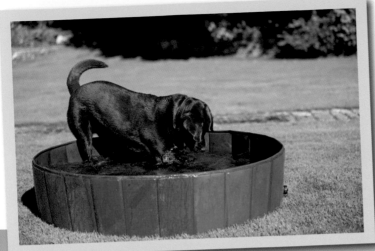

Now he's famous, Barnaby
has his own pool, flown
in from Italy no less.

Edward Scissordog

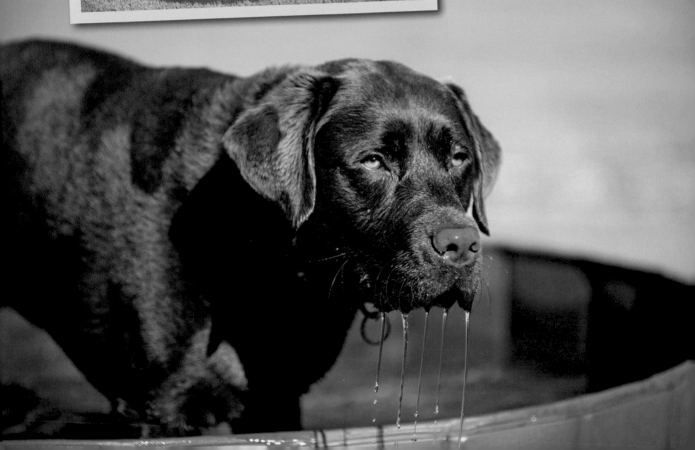

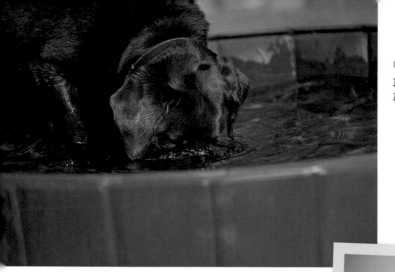

Getting a large pebble out of the pool is an hour-long job, you know.

Kongs don't float, so deep-sea diving sessions are required.

"No Dilly, this is a private pool, members only..."

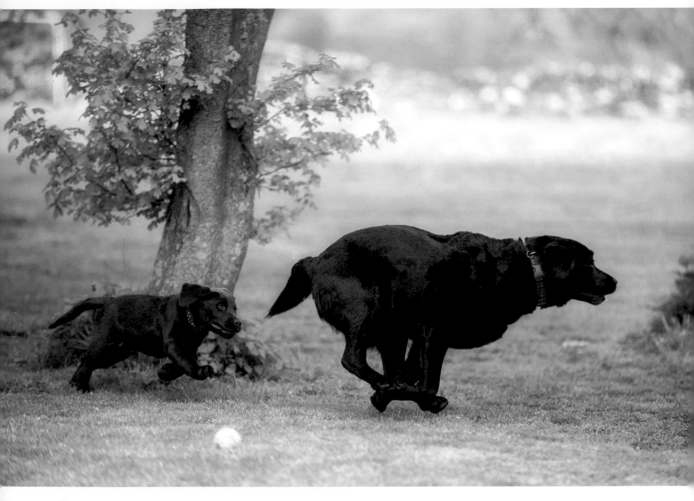

"Those were the days! Chasing my big sis Dilly was sooooo much fun, she always went just slow enough for me to nearly catch her tail."

"Mum, I found your slipper in the garden again, along with the tea towel, a football boot, and a Tupperware box. I don't know how they got there, honest!"

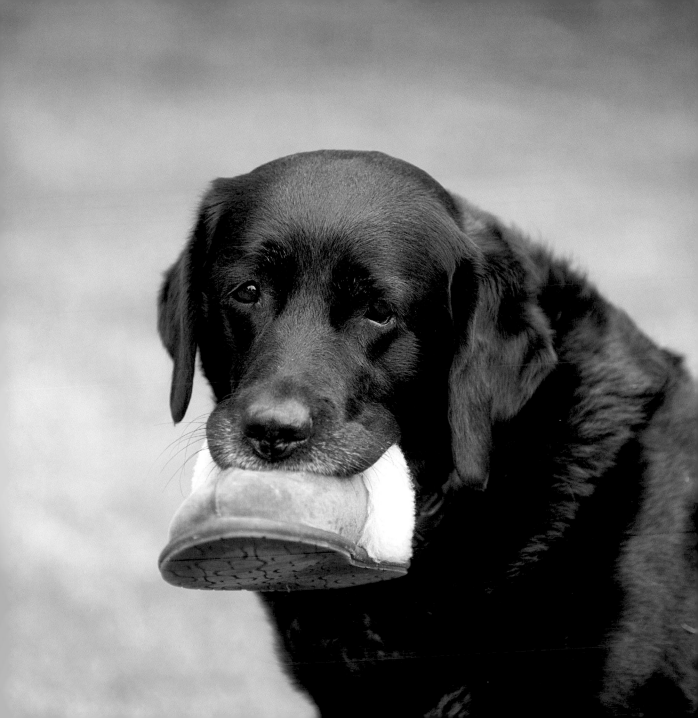

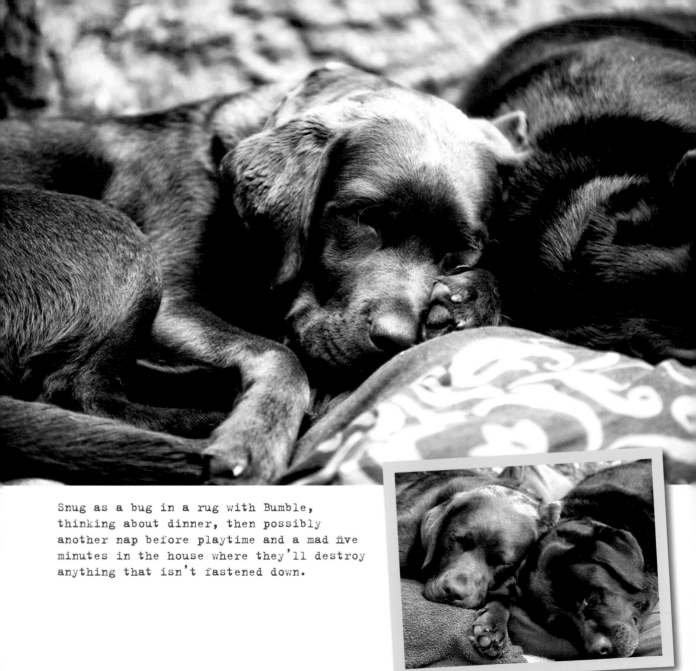

Snug as a bug in a rug with Bumble,
thinking about dinner, then possibly
another nap before playtime and a mad five
minutes in the house where they'll destroy
anything that isn't fastened down.

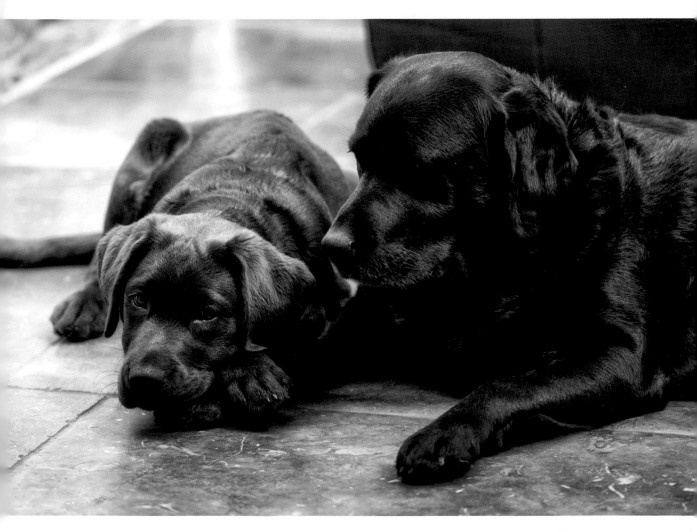

As a puppy, Barnaby was always at his comfiest
knowing one or both of his big sisters was within
touching distance. He dreamt of being as famous as
his sister Dilly one day—and now he is!

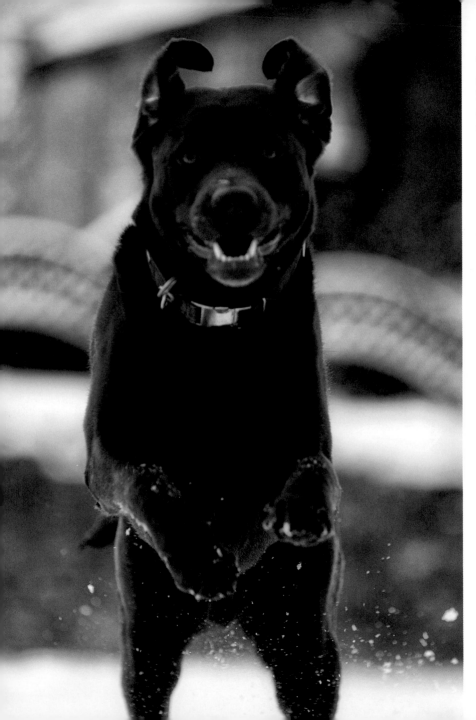

"This is my best friend and next-door neighbor Rigsby! He's always fooling around, and we do love to play in the snow together!"

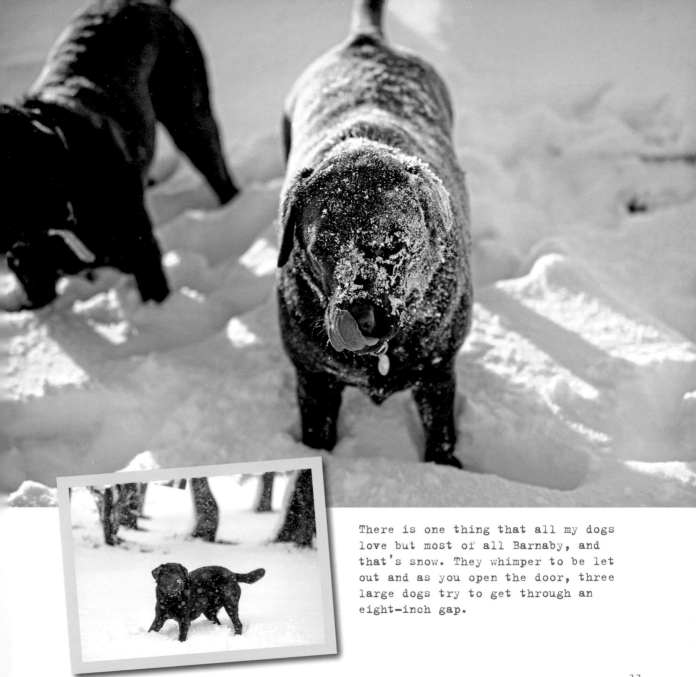

There is one thing that all my dogs love but most of all Barnaby, and that's snow. They whimper to be let out and as you open the door, three large dogs try to get through an eight-inch gap.

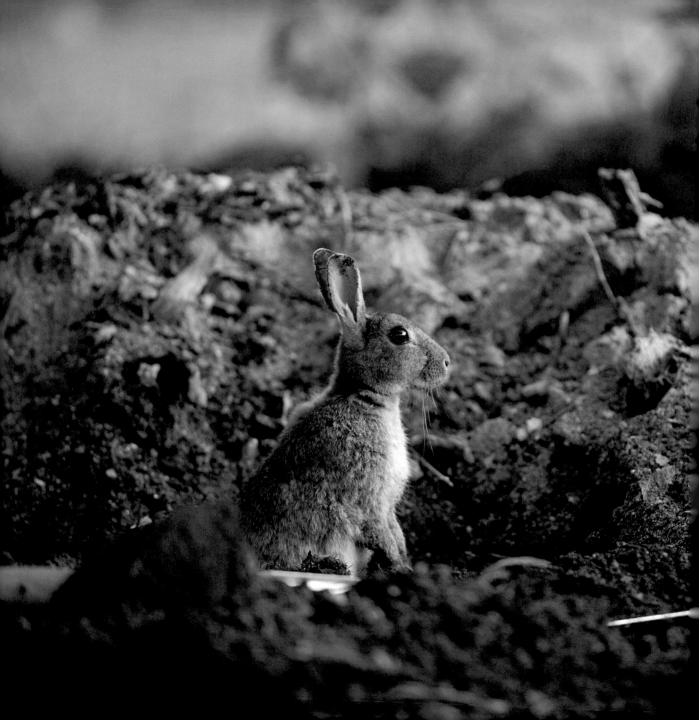

feathered &
furry friends

Right: Bobbin is our
farm robin, she comes
to sit wth me and the
dogs daily, and is a
wonderful addition to
our home.

Left: Remember that
Marylin Monroe movie?

When I was in the woods
with Barnaby one day,
we sat down on a bench
near the fence, and who
should come out but
Bobbin with her baby.
It made my day.

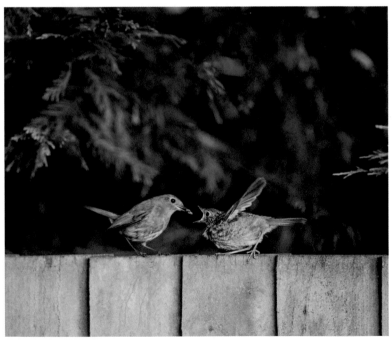

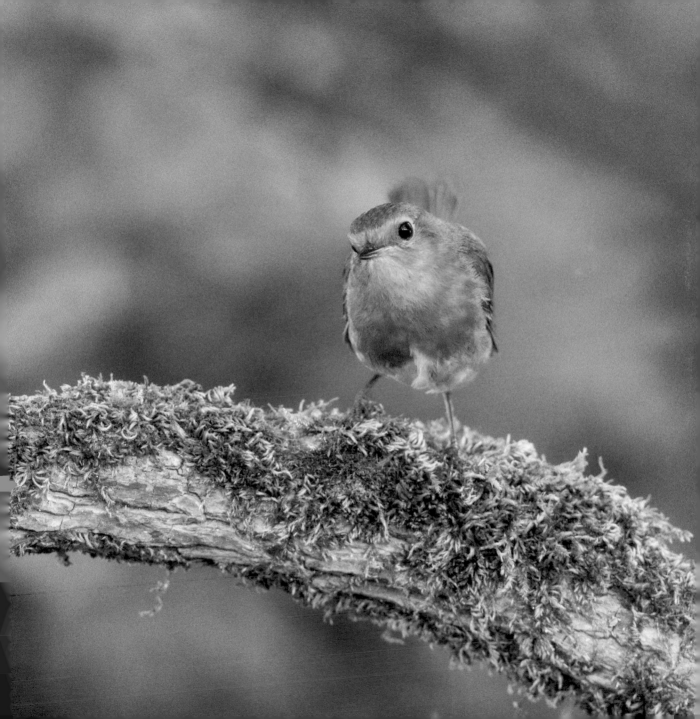

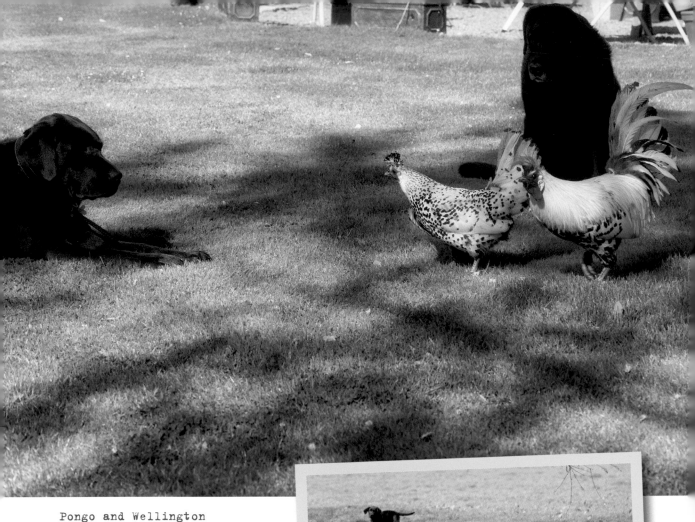

Pongo and Wellington
consider the rather slim
window of opportunity they
have to go through to get
their dinner. They can both
remember when Barnaby was a
puppy, and loved to chase
them round the garden.

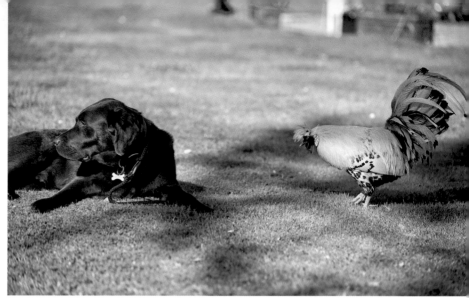

"There's a worm right by his paw, if I just tiptoe up quietly I'm sure I can get it."

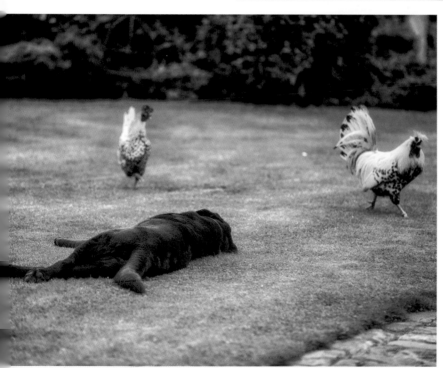

"Come on Pongo, he's snoring, let's go for it!"

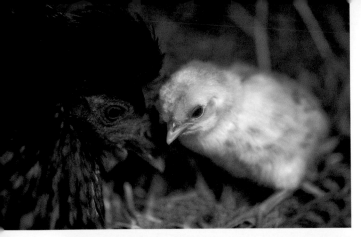

Mango, our new chick, says hello to the world at one day old.

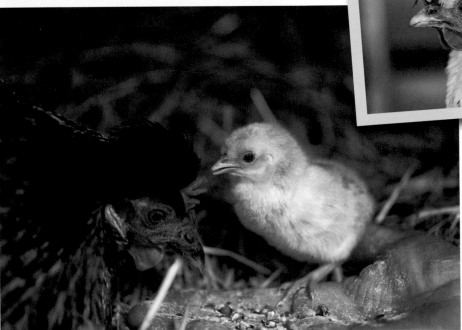

Digging that headgear Pongo!

Tikka teaches Mango what food is all about

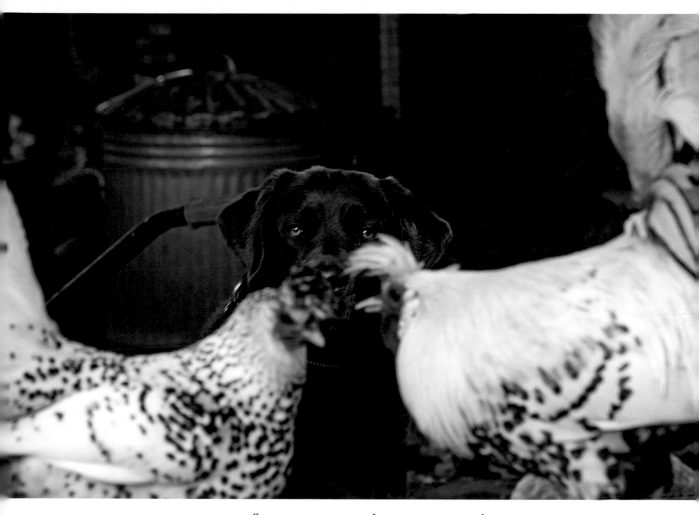

"OK Pongo, I don't think anyone's watching, you go and get the food and I'll keep a lookout." Barnaby's ability to sneak up on the chickens has only improved with age.

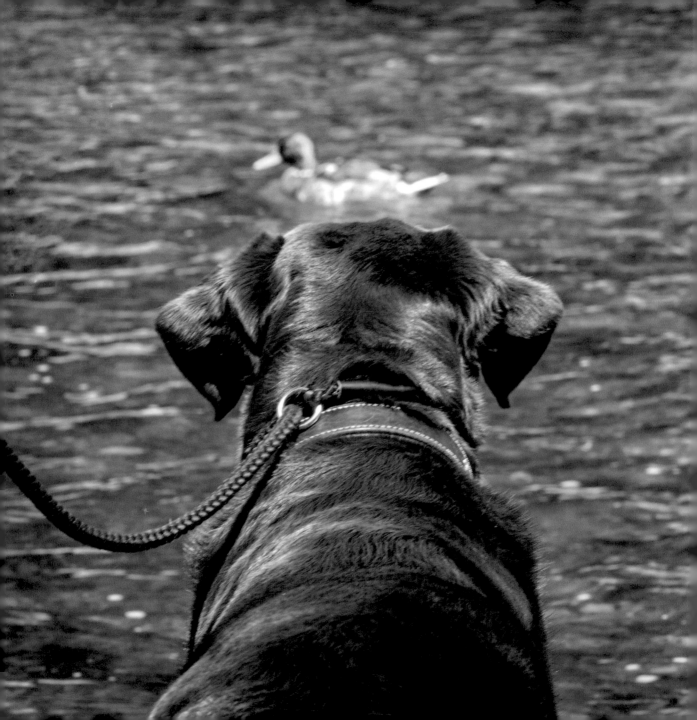

"I can see fish mum!"

"And ducks. I love ducks! Just let me off this leash, pleeeeeeease."

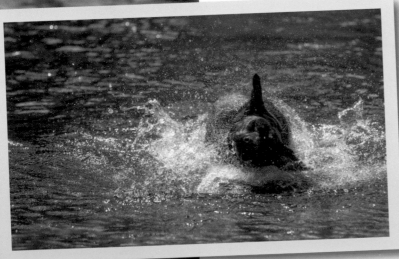

"Oh no, where did they all go? Oh well, I'll just have a bit of a splash around."

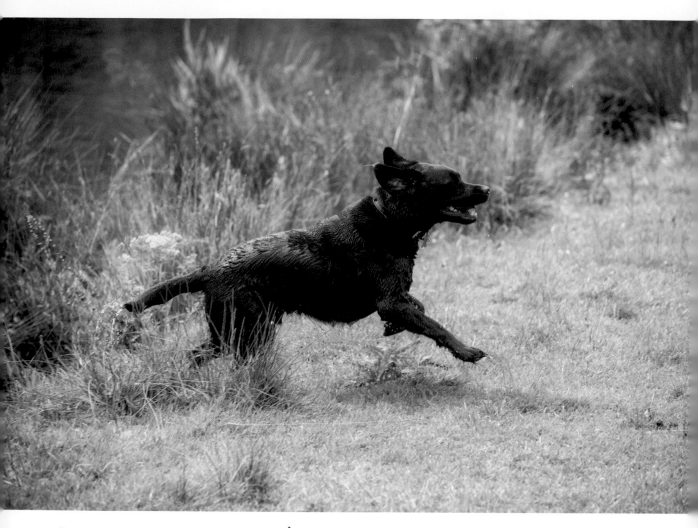

Everyone get out of the way, he's going to shake himself dry!

This is Beatrice. She's not scared of Barnaby and will come quite close to him as he lies there watching, with his head on his paws.

Rabbits, on the other hand, stay well away from him—I can't think why.

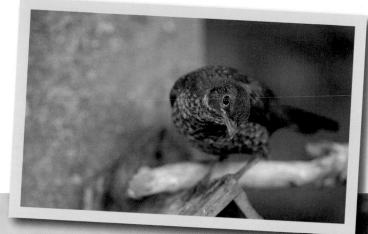

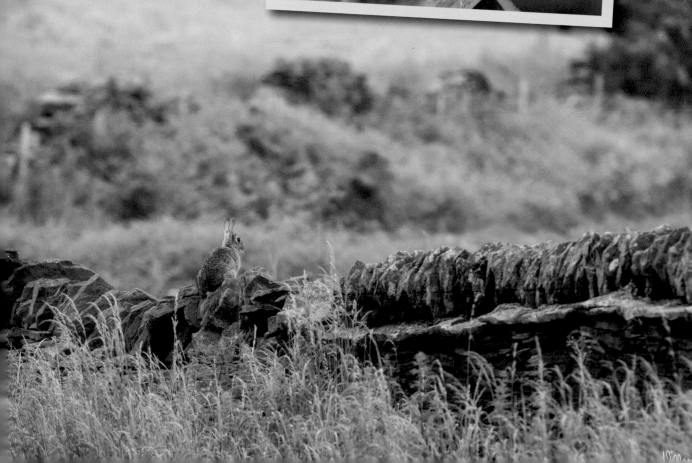

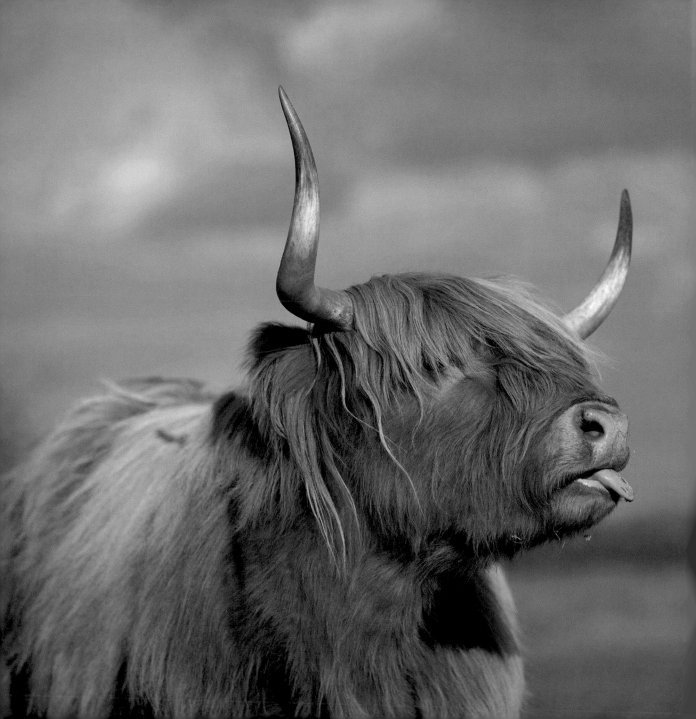

four-legged friends

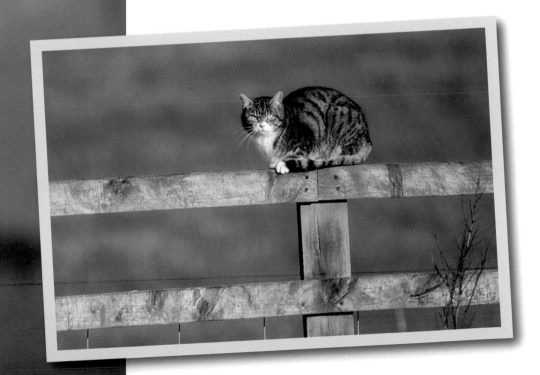

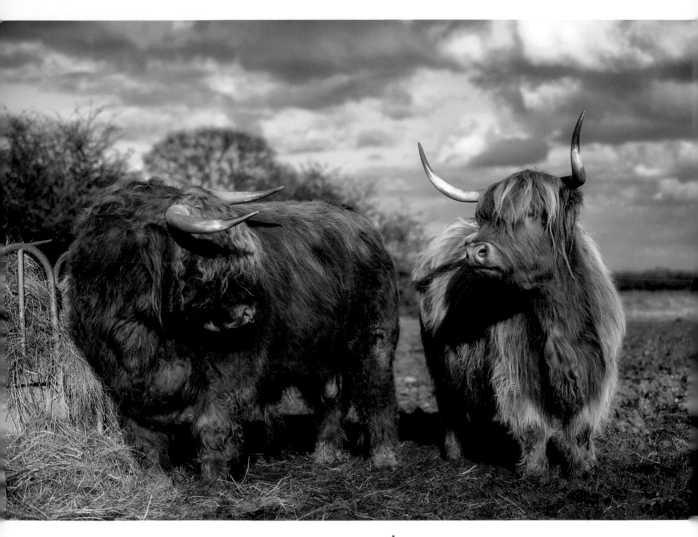

Jimbo the bull belongs to a friend of ours-he's amazing,
gentle but huge (Jimbo that is, not the friend)!

This Highland cow loves to play hide and seek in the woods! Unfortuantely he's quite easy to find, as he sticks out either side of the tree, but we pretend not to notice.

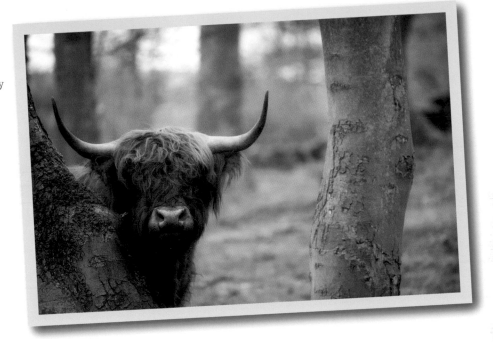

Mum knows best, and a good clean round the ears is a great start to the morning.

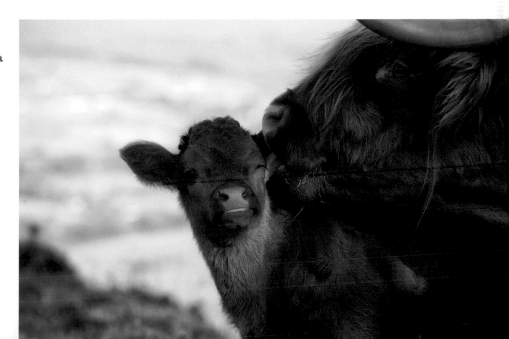

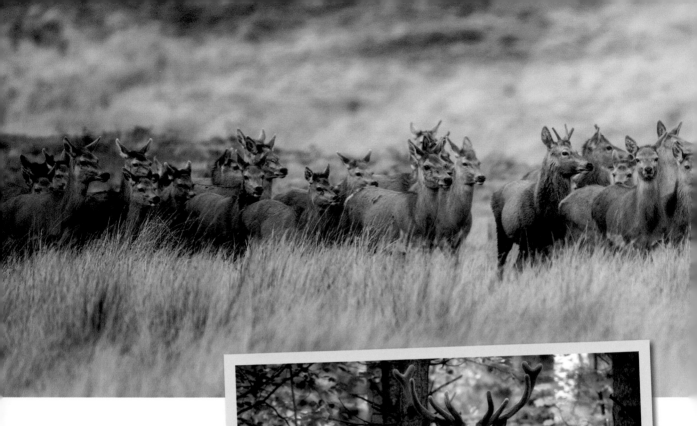

There's nothing like coming across a couple of full grown stags just yards away to wake you up first thing in the morning! It's better than any power shower, I can assure you.

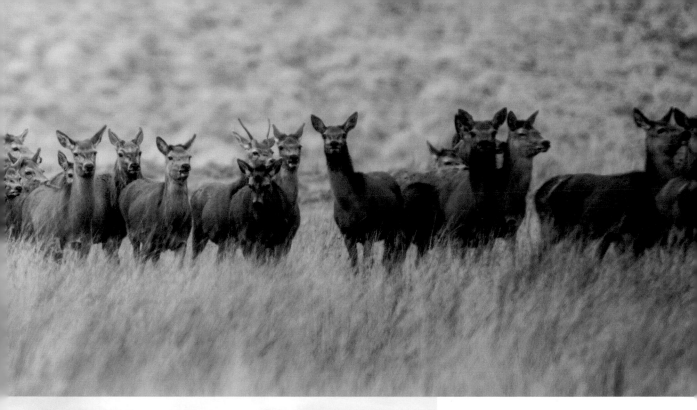

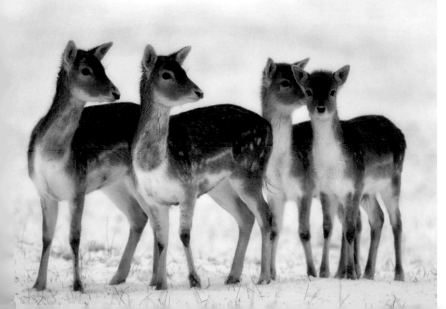

Above: Red deer are always with us on the moors where we walk and it's so beautiful to see them, wild and free!

Left: The button-nose gang. Out with my camera on our walks, we often come across fallow deer

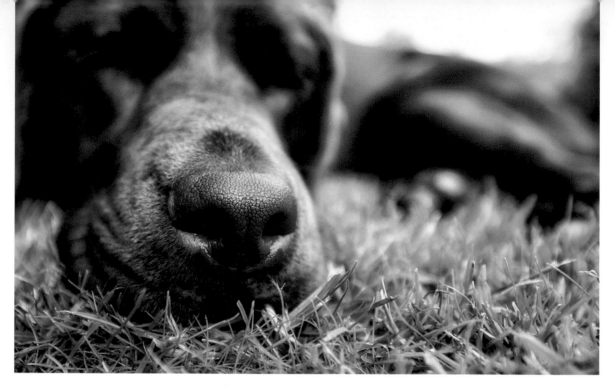

A wet nose means one of two things—Barnaby is
very healthy (which he is), or the boot room is
now an inch deep in water slopped from his bowl.

Bertie the horse was actually snoring when I took this
photo, then he woke with a start and you could tell he
didn't know where he was. I was laughing so much as he
realized he'd just been asleep and all was well.

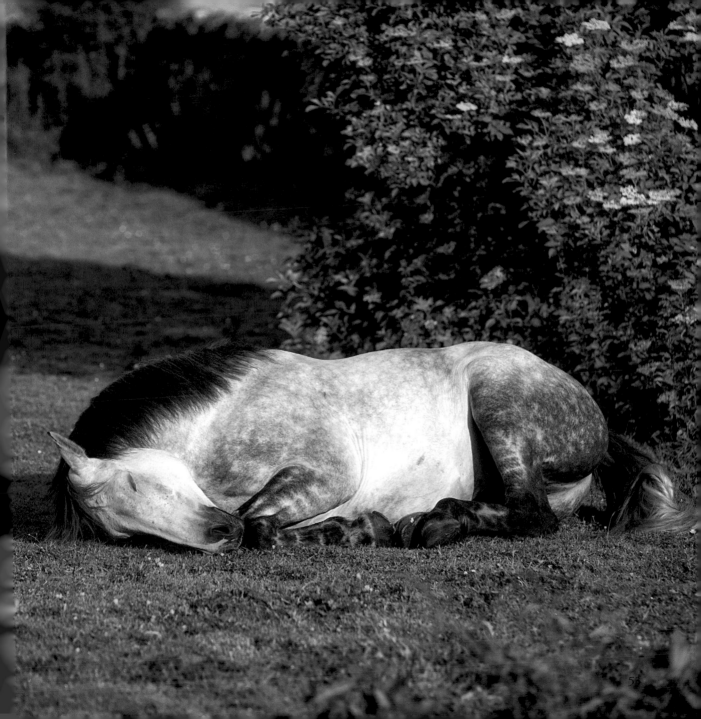

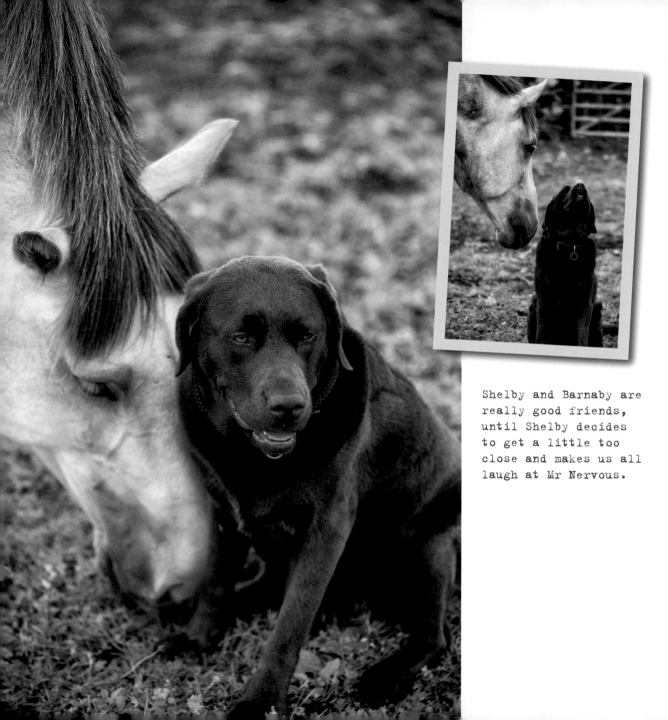

Shelby and Barnaby are really good friends, until Shelby decides to get a little too close and makes us all laugh at Mr Nervous.

Shelby decides to have a word in Barnaby's ear—doesn't he know that it's rude to stick your tongue out?

We often wonder where Barnaby has got to, and then we find he's gone up the field to sit with his other good friend, Bertie!

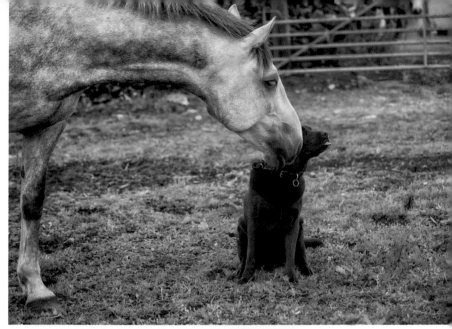

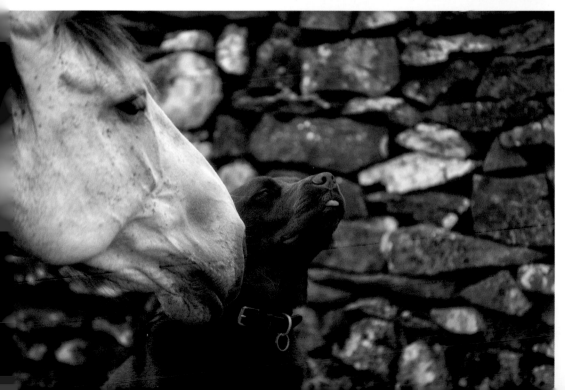

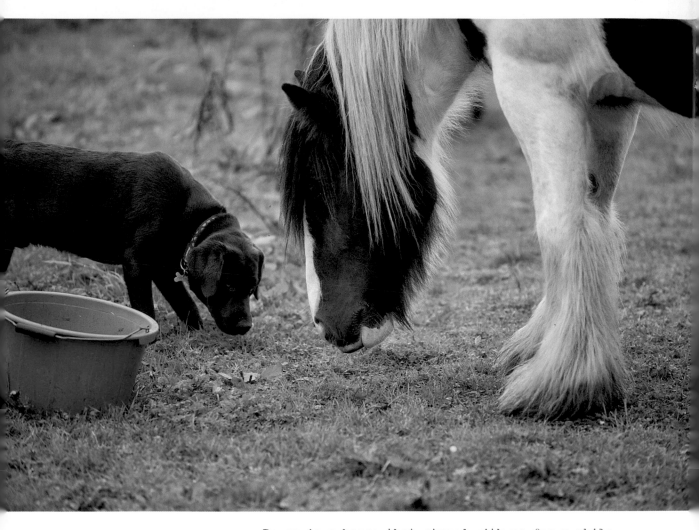

Roman is a horse that stayed with us for a while.
Barnaby is at this moment asking him if he would
mind sharing his breakfast.

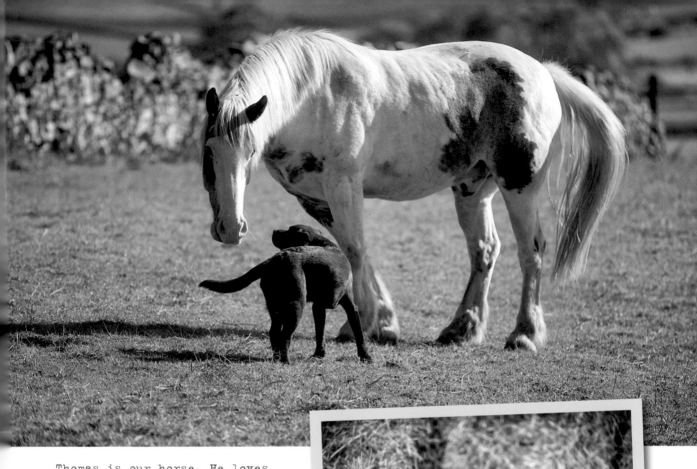

Thomas is our horse. He loves
Barnaby and follows him all
over the field as he looks for
rabbits to chase (but the
rabbits are always way too fast
for Barnaby, sadly).

Barnaby in his favorite place on
the whole farm, the horse stable.

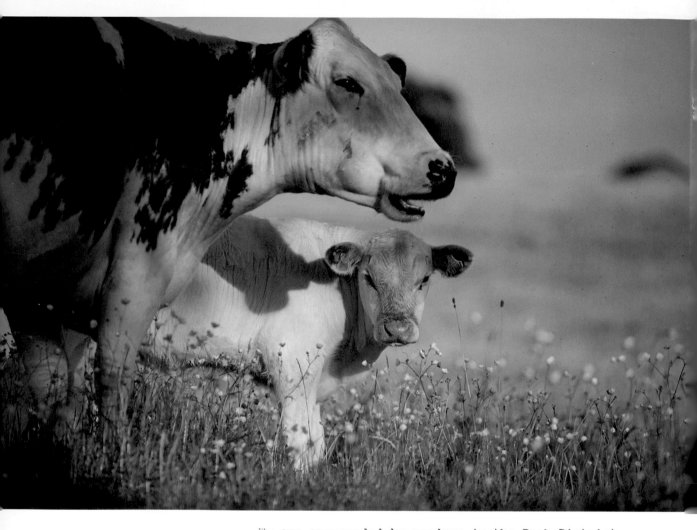

We are surrounded by meadows in the Peak District.
Summer really is a special time to wander round the
lanes and see the animals and the wildflowers.

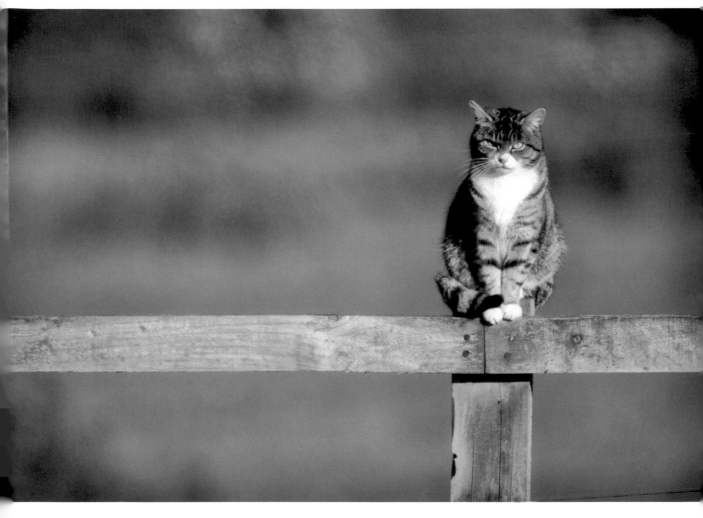

Mrs Grumpy Knickers—this is a cat that we pass
sometimes and I'm pretty certain she doesnt like
Barnaby. Can't you can tell by the look on her face?

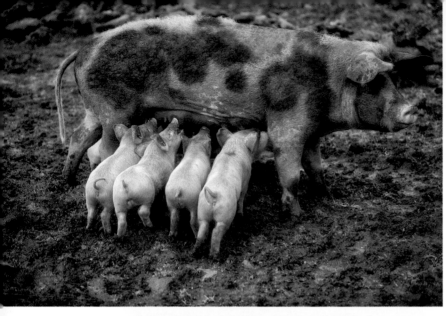

There is a field we pass which is full of piggies, and Barnaby is always rather too keen to stop and watch. I think he's getting some ideas about a mud bath.

Right: Dozing off at any given moment is one of Rebecca the lama's favorite hobbies.

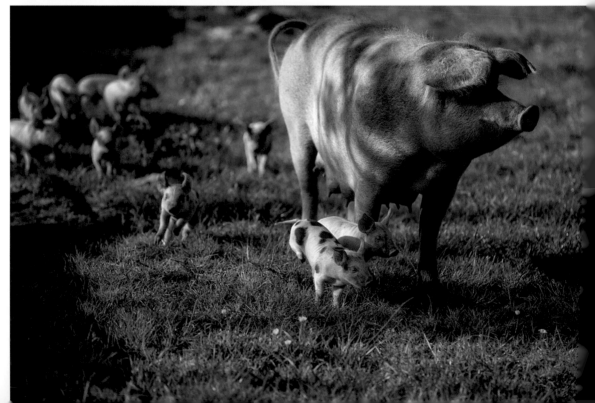

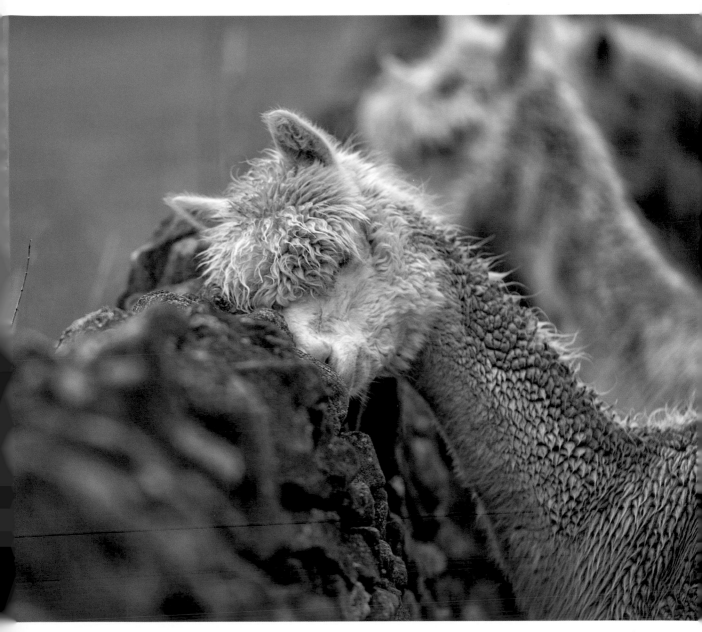

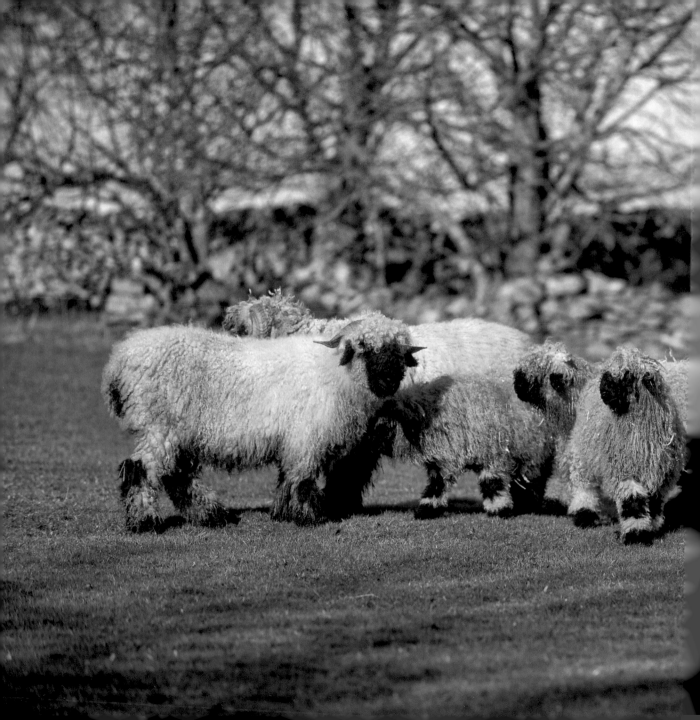

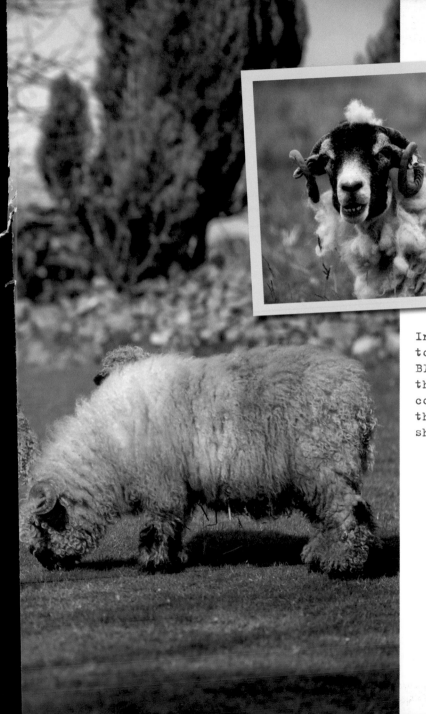

In Derbyshire, the sheep like to follow fashion. These Valais Blacknose sheep (left) model the classic black-and-white combination with a twist, while the sheep above goes for the shabby chic look.

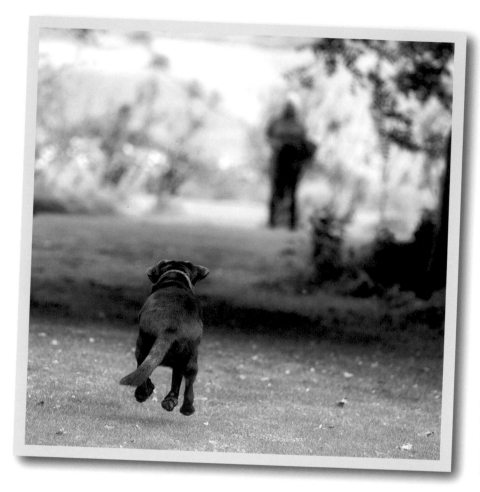

"When mum's best friend Liz arrives for walkies, am I pleased to see her or what?"

Acknowledgments

Villager Jim would like to thank his gorgeous pets Bumble, Dilly, and Barnaby for being part of his family, and he would like to dedicate this book to each and every one of his amazing followers on Facebook, because without them none of this would have happened.

villagerjimsshop.com

Experience a world of wildlife with Villager Jim and his camera as
he wanders down country lanes and peers into hedgerows each morning.
You will meet rabbits, deer, foxes, hares, owls, and pheasants.
Villager Jim knows them all by name—but no-one knows who he is.

Visit www.**villagerjimsshop.com** for the full range of products.

canvases coasters glass worktop savers oven gloves

wash bags jigsaws cushions

iPhone covers

greeting cards